the declaration of
INTERDEPENDENCE

TARA CULLIS

DAVID SUZUKI

with

RAFFI CAVOUKIAN

WADE DAVIS

GUUJAAW

art by

MICHAEL NICOLL YAHGULANAAS

the DECLARATION
of INTERDEPENDENCE

A Pledge to Planet Earth

SPECIAL 30TH ANNIVERSARY EDITION

DAVID SUZUKI INSTITUTE

GREYSTONE BOOKS
Vancouver/Berkeley/London

Greystone Books Ltd.
greystonebooks.com

David Suzuki Institute
219 – 2211 West 4th Avenue
Vancouver, BC, Canada V6K 4S2

Cataloguing data available from Library and Archives Canada
ISBN 978-1-77840-004-9 (cloth)
ISBN 978-1-77840-005-6 (epub)

Copy editing for the anniversary edition by Jess Shulman
Proofreading by Alison Strobel
Jacket and interior design by Heather Pringle
Jacket artwork by Michael Nicoll Yahgulanaas

Printed in Canada on FSC® certified paper at Friesens. The FSC® label
means that materials used for the product have been responsibly sourced.

Greystone Books gratefully acknowledges the Musqueam, Squamish, and
Tsleil-Waututh peoples on whose land our Vancouver head office is located.

Greystone Books thanks the Canada Council for the Arts,
the British Columbia Arts Council, the Province of British Columbia
through the Book Publishing Tax Credit, and the Government
of Canada for our publishing activities.

Canada

For Tamo, Midori, Jonathan, Ganhlaans,
Tiisaan, Ryo, Setsu, Kaoru, Nakina—
"all those who will walk after us"
—who are our conscience and our inspiration

TARA CULLIS *and* DAVID SUZUKI

CONTENTS

the declaration of
INTERDEPENDENCE

THIS WE *know*

We are the earth,

through the plants and animals that nourish us.

We are the rains and the oceans

that flow through our veins.

We are the breath of the forests of the land,

and the plants of the sea.

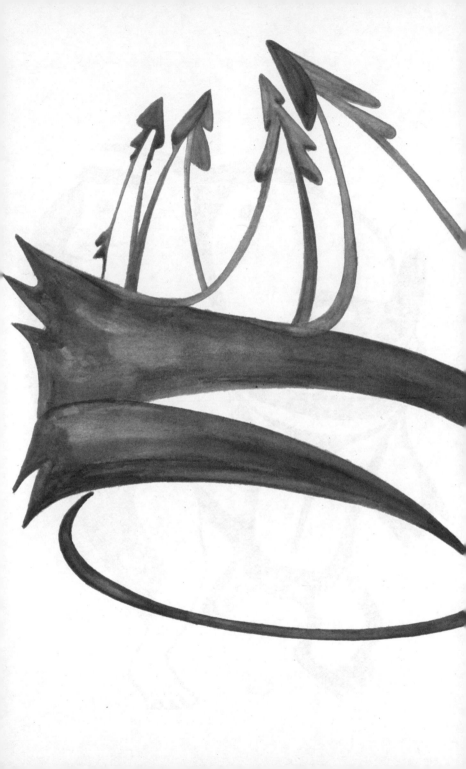

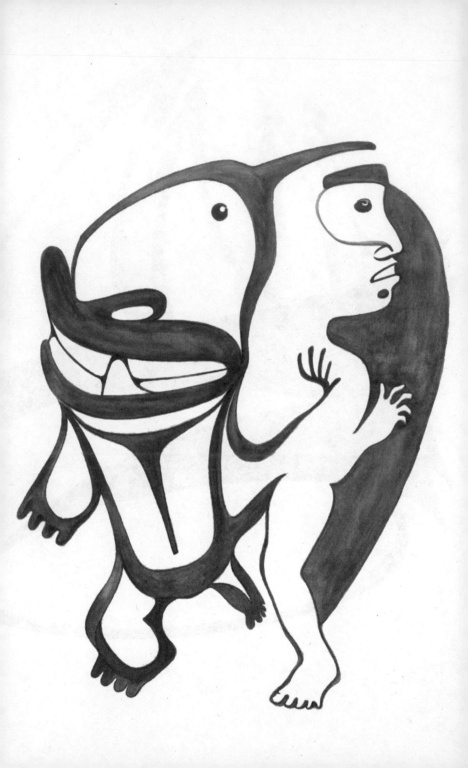

We are human animals,

related to all other life

as descendants of the firstborn cell.

We share with these kin a common history,

written in our genes.

We share a common present, filled with uncertainty.

And we share a common future, as yet untold.

We humans are but one

 of thirty million species

weaving the thin layer of life enveloping the world.

 The stability of communities of living things

 depends upon this diversity.

 Linked in that web, we are interconnected—

using, cleansing, sharing, and replenishing

 the fundamental elements of life.

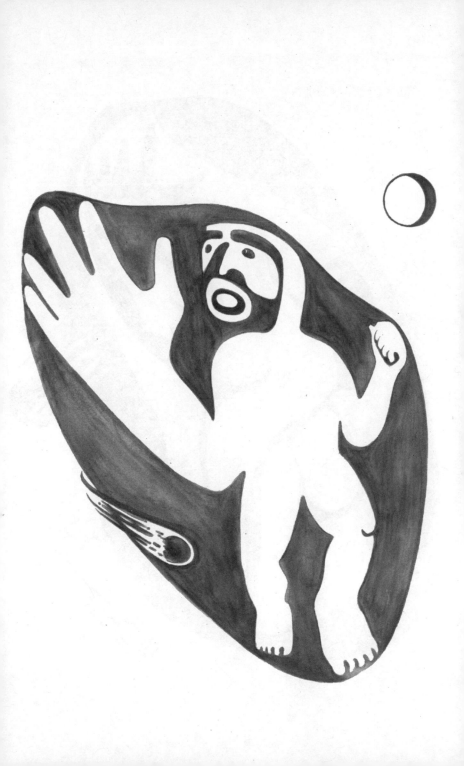

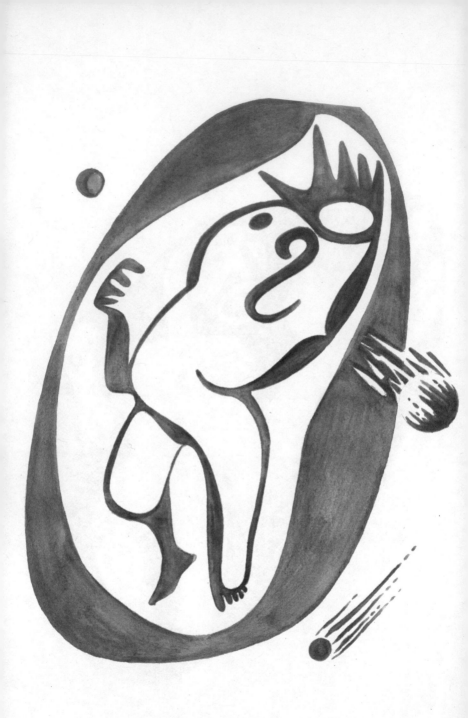

Our home, planet Earth, is finite;

all life shares its resources and the energy from the sun,

and therefore has limits to growth.

For the first time, we have touched those limits.

When we compromise the air,

 the water, the soil, and the variety of life,

we steal from the endless future

 to serve the fleeting present.

THIS WE *believe*

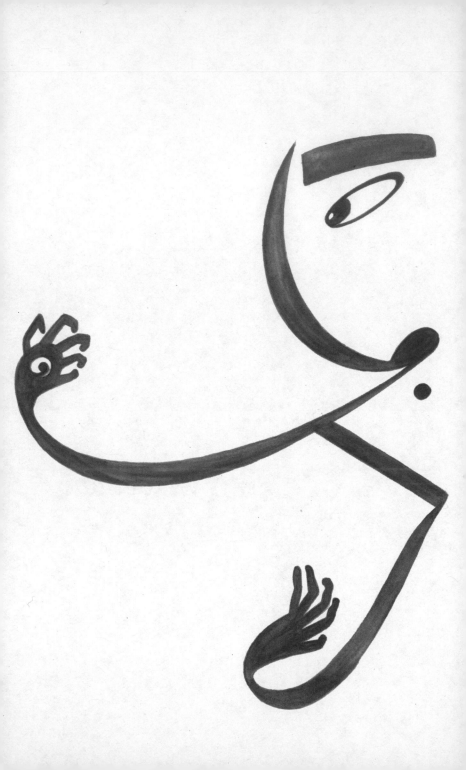

Humans have become so numerous

and our tools so powerful

that we have driven fellow creatures to extinction,

dammed the great rivers, torn down ancient forests,

poisoned the earth, rain, and wind,

and ripped holes in the sky.

Our science has brought pain as well as joy;

our comfort is paid for by the suffering of millions.

We are learning from our mistakes,

we are mourning our vanished kin,

and we now build a new politics of hope.

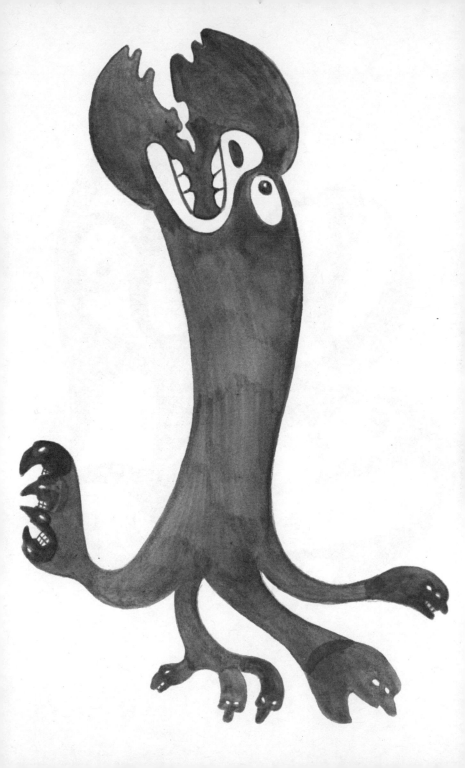

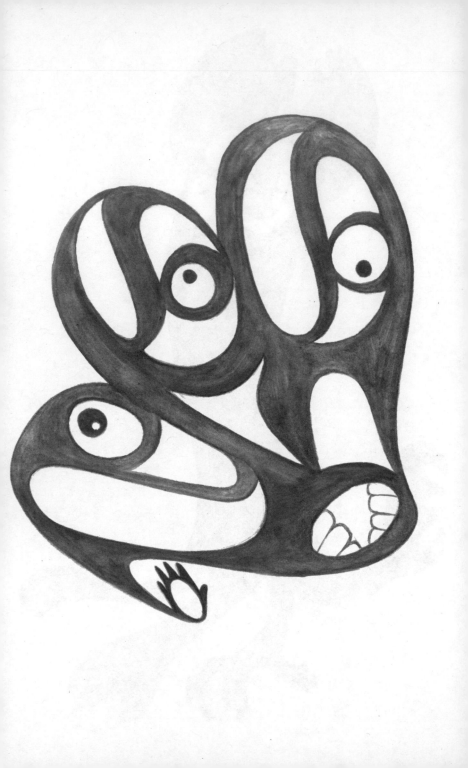

We respect and uphold the absolute need

for clean air, water, and soil.

We see that economic activities that benefit the few

while shrinking the inheritance of the many are wrong.

And since environmental degradation

erodes biological capital forever,

full ecological and social cost must enter all

equations of development.

We are one brief generation in the long march of time;

the future is not ours to erase.

So where knowledge is limited,

we will remember all those who will walk after us,

and err on the side of caution.

THIS WE *resolve*

All this that we know and believe

must now become the foundation of the way we live.

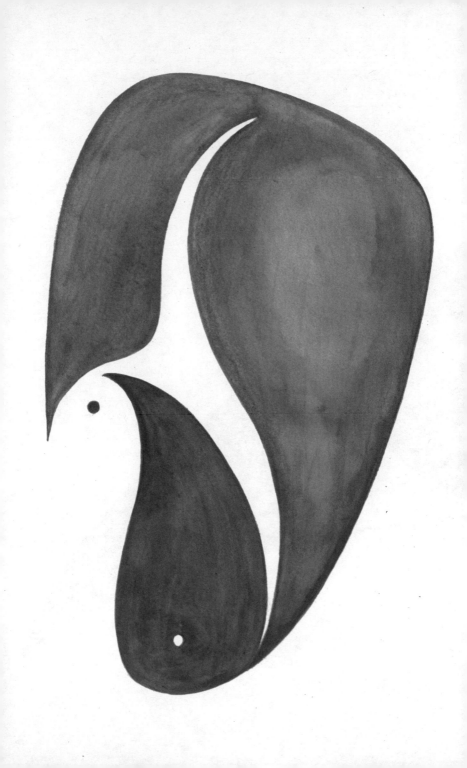

At this turning point in our relationship with Earth,

we work for an evolution:

from dominance to partnership;

from fragmentation to connection;

from insecurity

to interdependence.

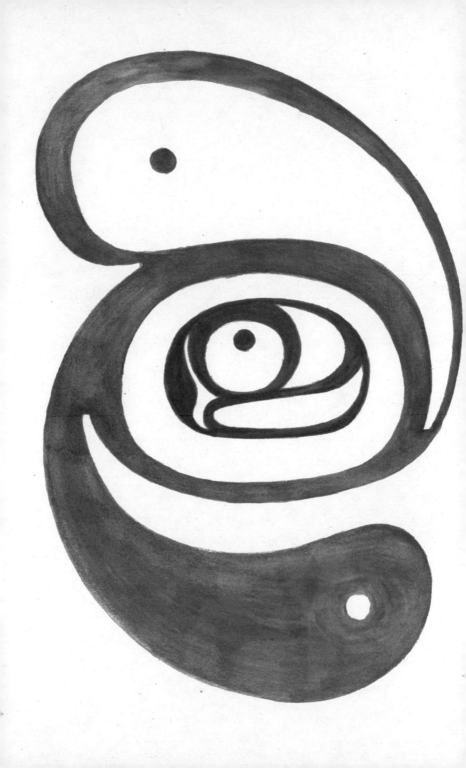

The Declaration of Interdependence

THIS WE KNOW

We are the earth, through the plants and
 animals that nourish us.
We are the rains and the oceans that flow
 through our veins.
We are the breath of the forests of the land,
 and the plants of the sea.
We are human animals, related to all other life
 as descendants of the firstborn cell.
We share with these kin a common history,
 written in our genes.
We share a common present, filled with
 uncertainty.
And we share a common future, as yet untold.
We humans are but one of thirty million species
 weaving the thin layer of life enveloping
 the world.
The stability of communities of living things
 depends upon this diversity.
Linked in that web, we are interconnected—
 using, cleansing, sharing, and replenishing
 the fundamental elements of life.
Our home, planet Earth, is finite; all life shares
 its resources and the energy from the sun,
 and therefore has limits to growth.
For the first time, we have touched those limits.
When we compromise the air, the water, the
 soil, and the variety of life, we steal from the
 endless future to serve the fleeting present.

THIS WE BELIEVE

Humans have become so numerous and our
 tools so powerful that we have driven fellow
 creatures to extinction, dammed the great
 rivers, torn down ancient forests, poisoned
 the earth, rain, and wind, and ripped holes
 in the sky.
Our science has brought pain as well as joy; our
 comfort is paid for by the suffering of millions.
We are learning from our mistakes, we are
 mourning our vanished kin, and we now
 build a new politics of hope.
We respect and uphold the absolute need for clean
 air, water, and soil.
We see that economic activities that benefit the
 few while shrinking the inheritance of the
 many are wrong.
And since environmental degradation erodes
 biological capital forever, full ecological
 and social cost must enter all equations of
 development.
We are one brief generation in the long march of
 time; the future is not ours to erase.
So where knowledge is limited, we will remember
 all those who will walk after us, and err on the
 side of caution.

THIS WE RESOLVE

All this that we know and believe must now
become the foundation of the way we live.

At this turning point in our relationship with
Earth, we work for an evolution: from
dominance to partnership; from fragmenta-
tion to connection; from insecurity to
interdependence.

The Declaration of Interdependence
—Thirty Years Later

DAVID SUZUKI
Co-founder, David Suzuki Foundation

"The Declaration of Interdependence" was composed in response to the Worldwatch Institute's designation of 1990 as the beginning of a turnaround decade that would shift humanity to a new, critical path toward sustainability.

Ever since 1962, when Rachel Carson galvanized people around the world with her book about the effects of pesticides, *Silent Spring*, millions of people had become part of a global environmental movement.

When Carson's book came out, there wasn't an environment department in any government in the world. Only fourteen years earlier, in fact, Paul Hermann Müller had received a Nobel Prize for his work on DDT.

But in 1970, the first Earth Day was held, and a decade after *Silent Spring* was published, the United Nations organized an international conference on the environment in Stockholm and created the United Nations Environment Programme.

Another two decades later, a remarkable document called the "World Scientists' Warning to Humanity"

was released, signed by over 1,700 senior scientists from seventy-one nations, including more than half of all Nobel laureates alive at that time.

It began:

"Human beings and the natural world are on a collision course. Human activities inflict harsh and often irreversible damage on the environment and on critical resources. If not checked, many of our current practices put at serious risk the future that we wish for human society and the plant and animal kingdoms, and may so alter the living world that it will be unable to sustain life in the manner that we know. Fundamental changes are urgent if we are to avoid the collision our present course will bring about."

The document went on to list the areas of collision—the atmosphere, water, oceans, soil, forests, species extinction, and population. Then the words grew even more bleak:

"No more than one or a few decades remain before the chance to avert the threats we now confront will be lost and the prospects for humanity immeasurably diminished ... We, the undersigned, senior members of the world's scientific community, hereby warn all humanity of what lies ahead. A great change in our stewardship of the earth and the life on it is required, if vast human misery is to be avoided and our global home on this planet is not to be irretrievably mutilated."

The warning concluded with "What we must do" in five recommendations:

1 "Bring environmentally damaging activities under control to restore and protect the integrity of earth's systems we depend on"
2 "Manage resources crucial to human welfare more effectively"
3 "Stabilize population"
4 "Reduce and eventually eliminate poverty"
5 "Ensure sexual equality, and guarantee women control over their own reproductive decisions"

This unprecedented plea for action by global leaders in science was released in anticipation of a gathering of 109 heads of state for the Earth Summit in Rio de Janciro, where the David Suzuki Foundation offered "The Declaration of Interdependence" to delegates in five languages.

Henceforth, conference participants declared, the environment must be considered in all aspects of human activity, thereby signalling that humanity was making a fundamental turn onto a sustainable path.

It was a remarkable moment in the history of our species, a signal that we had become so powerful we had to rein ourselves in.

How did we achieve this position?

The stock market crash of 1929 was followed by a terrible prolonged period called the Great Depression.

Then World War II plunged us into a brutal period in our history that claimed millions of lives.

War had an unplanned consequence: it ignited the American economy into an enormous period of productivity that carried beyond the war's end into peacetime

by turning civil society toward consumerism, with a throwaway mentality that ensured an endless market for goods.

But there was a cost to this postwar economic expansion. Rachel Carson's book, in exposing the unexpected effects of pesticides, served as a warning about the consequences of treating the planet simply as a vast source of raw material and a sewer for our products.

Pollution by pesticides was just one of many critical issues. Others included logging practices, megadams, ozone depletion, overfishing, and global warming.

In June 1988, reflecting growing concern about the effect of emissions on the air, some three hundred delegates attended a conference titled The Changing Atmosphere: Implications for Global Security.

Most attendees were scientists and a few came from environmental NGOs, but what the media responded to was the ministerial interest from forty-six countries and attendance by twenty-nine government ministers and two prime ministers (from Canada and Norway).

The press release at the end of the conference contained a stark warning: "Humanity is conducting an unintended, uncontrolled, globally pervasive experiment whose ultimate consequences could be second only to a global nuclear war." It proposed a specific initial target for a global reduction in the emission of carbon dioxide—20% below 1988 levels by 2005—on the way to a much larger ultimate reduction, to be set following further research and debate.

Numerous studies in different countries, including Canada and the United States, concluded that the

proposed target could be achieved at a cost of tens of billions of dollars, but would improve health and result in net savings of tens of billions in return.

But the proposal made no sense in a political arena where the initial costs would elicit enormous opposition, while the benefits would only be reaped fifteen years later, by other politicians altogether.

And so, three decades after Carson's book, environmental problems had fuelled widespread public concern.

This broad public awareness of civil society and demand for action led to the UN-sponsored 1992 Earth Summit.

Heading into the summit, we felt an uplifting statement was needed, to help put humans in the proper context within the web of life or what we call "nature."

The conjunction of a number of changes in humanity's ecological impact made this imperative.

The first change was the exponential growth in human numbers.

It took all of human existence for us to reach a billion people in the early 1800s, but a century later when I was born (in 1936), that number had doubled. It then doubled (to four billion) and had redoubled (to almost eight billion) by the middle of my eighth decade.

Every human being in the world must breathe air, drink water, and eat food, while needing clothes and shelter, so just the act of staying alive means that our collective ecological footprint (the amount of air, water, land, and renewable resources consumed) is enormous.

But human creativity and invention have enabled us to escape the limits and constraints imposed by

biology with telescopes, microscopes, vehicles, and machines that enable us to see farther, get closer, travel faster, extract more, produce more quickly, and release vast quantities of effluent. We are now altering the very life support systems of the planet—air, water, soil, and photosynthesis.

As Rachel Carson pointed out with DDT, we are a clever animal but lack sufficient knowledge to anticipate and hence avoid the deleterious consequences of our inventiveness.

How could we have predicted that widespread spraying of chemical compounds on farmers' fields would end up concentrating them in the shell glands of birds and breasts of women, when biomagnification was only discovered as a phenomenon when raptors began to disappear and scientists tracked down the cause to pesticides?

Our technological wizardry has opened up the planet from mountaintops to ocean depths, from Arctic tundra to steaming rainforests to the core of the earth for our ever-increasing extractive demands.

We are making over the planet to serve ourselves, without an overarching understanding of where we belong.

The economic system has grown by embracing consumption in the service of our wants, not our needs, as its critical driver, in the mistaken belief that endless growth is both possible (which it is not) and the very measure of success and progress.

No one wants to deter "progress," but when it is defined by growth, it becomes a malignancy with only one consequence: death.

To compound the problem, the economy does not account for the fact that human survival and well-being are utterly dependent on nature's abundance and productivity, from the oxygenation of the atmosphere and capture of the sun's energy by photosynthesis, to the cleansing of water within the hydrologic cycle, to the creation of soil and provision of every bit of our nutrition.

Lacking that understanding means there is little sense of a "responsibility" within economics to act properly to ensure nature's continuing providence.

Globalization of such a defective economic construct has been the primary factor propelling humanity on its destructive course.

In following the biblical injunction to go forth and multiply, and fill the earth and subdue it, we are driven along an unsustainable path.

But at the very moment when population, technology, and globalization of the economy have become so immense, we have shifted from rural village communities to big cities where nature seems "out there," away and separate from our primary habitat.

The word economy originates from the Greek word *oikos*, meaning household or domain.

Economics is the management of home, while ecology is its study.

Ecologists inform us of the factors vital to long-term survival in our home, the biosphere, which should be the underpinnings of economics.

It would seem most prudent for ecological principles to subsume economic activity, yet when

then Prime Minister of Canada Stephen Harper refused to discuss climate change and referred to control and reduction of greenhouse gas (GHG) emissions as "crazy economics," he elevated the economy above the atmosphere that provides life-giving air and shapes the weather, the climate, and the seasons.

By elevating human wants, and human constructs like the economy and human borders, above nature and its requirements to flourish, we have extracted ourselves from what humanity has known and understood since we first evolved:

We are biological creatures whose animal nature dictates an immutable need for pure air, clean water, rich soil, and abundant and diverse plants and other animals for our well-being and survival.

For most of our existence since our species evolved on the great grasslands of Africa, we lived as nomadic hunter-gatherers following animals and plants through the seasons.

We understood that we are inextricably bound up in a web of relationships with all other species and air, water, soil, and sunlight, an ecocentric way of seeing our place that has been supplanted with a belief that we are at the centre of the action, the dominant animal around whom everything revolves in our service (the "anthropocentric" world view).

We recognize the great human feats as the Bronze Age, the Agricultural Revolution, the Industrial Revolution, the Urban Explosion, and the Space Age, periods of achievement that pumped up our self-esteem and

seemed to extricate us from the web of relationships that we had so long acknowledged and celebrated.

In genetics, my area of expertise, researchers have deciphered the entire human genome and developed astonishing techniques and tools to manipulate DNA, so now we not only contemplate fixing deleterious genetic conditions, but we also foresee improving the genetic blueprint to create "superior" beings, even as we anticipate the ultimate "improvement" as cyborgs.

But "improved," "better," or "superior" are not scientifically meaningful descriptions. They are value judgments for which there can be a wide range of opinions.

It has never been more important to acknowledge that while we have been remarkably inventive, our ignorance about our relationships with the rest of nature is so great that we inevitably create problems when we apply our impressive technologies on a grand scale.

That's what *Silent Spring* warned about.

When atomic bombs were dropped over Japan, scientists did not know about radioactive fallout, electromagnetic pulses of gamma rays, or the possibility of a nuclear winter or fall.

Chlorofluorocarbons (CFCs) were hailed as chemical miracles, large complex molecules that were chemically inert and useful as refrigerants or filler for spray cans, but no one could have anticipated their destructive reaction with ozone.

Over and over, we are confronted with the destructive consequences of elevating our innovations without regard to the biosphere within which they are exploited.

Through the 1970s and '80s, battles heated up over clear-cut logging practices in old-growth forests; nitrogen runoff from agricultural use of artificial fertilizers; accumulation of plastics in oceans already depleted by longlines, drift nets, salmon aquaculture, and bottom trawlers; and toxic compounds in air, water, and soil that inevitably end up in human bodies.

In 2017, a second "World Scientists' Warning to Humanity" was issued, this time signed by more than fifteen thousand scientists. It read:

"Since 1992, with the exception of stabilizing the stratospheric ozone layer, humanity has failed to make sufficient progress in generally solving these foreseen environmental challenges, and alarmingly, most of them are getting far worse... Especially troubling is the current trajectory of potentially catastrophic climate change due to rising GHGs from burning fossil fuels, deforestation, and agricultural production—particularly from farming ruminants for meat consumption. Moreover, we have unleashed a mass extinction event, the sixth in roughly 540 million years, wherein many current life forms could be annihilated or at least committed to extinction by the end of this century."

Scientists are now documenting the degradation of Earth in dozens of areas from polar ice to loss of earthworms.

The second "Warning to Humanity" is urgent, and it concludes:

"To prevent widespread misery and catastrophic biodiversity loss, humanity must practice a more environmentally sustainable alternative to business as usual. This prescription was well articulated by the world's leading scientists 25 years ago, but in most respects, we have not heeded their warning. Soon it will be too late to shift course away from our failing trajectory, and time is running out. We must recognize, in our day-to-day lives and in our governing institutions, that Earth with all its life is our only home."

In October 2018, the Intergovernmental Panel on Climate Change issued a special report concluding that human emissions of greenhouse gases were on a trajectory to increase global temperature by 3° to 5°c above pre-industrial levels by 2100.

Such a rise would be catastrophic but might be avoided by reducing emissions by 45% by 2030 and 100% by 2050. Already, two years have passed, and emissions have continued to rise.

In May 2019, yet another authoritative report (by the Intergovernmental Science-Policy Platform on Biodiversity and Ecosystem Services (IPBES)) concluded: "Nature is declining globally at rates unprecedented in human history—and the rate of species extinctions is accelerating, with grave impacts on people around the world now likely."

IPBES Chair Sir Robert Watson warned, "The health of ecosystems on which we and all other species depend is deteriorating more rapidly than ever. We

are eroding the very foundations of our economies, livelihoods, food security, health and quality of life worldwide."

Watson went on, "It is not too late to make a difference, but only if we start now at every level from local to global. Through 'transformative change,' nature can still be conserved, restored and used sustainably... By transformative change, we mean a fundamental, system-wide reorganization across technological, economic and social factors, including paradigms, goals and values."

This is the Anthropocene, the Age of Humans, when we have become the primary cause of alteration of the physical, chemical, and biological properties of the planet on a geological scale.

The global pandemic of a virus, COVID-19, has brought modern society to its knees. Yet it's provided an inspiring indication of what humanity is capable of in sharing, caring, and acting together to confront a common threat—a moment to recalibrate and work toward a post-COVID-19 world that is more just, equitable, and ecologically balanced.

The ecological crisis is a direct result of our anthropocentricity. It is imperative that we see the barriers imposed by the elevation of human constructs above everything else, the systems within which we act:

Legal systems define human rights, property rights, and jurisdictions, but where is the right of a bird to live out its life as it evolved to do, the right of a forest to flourish as a community of organisms, or the right of a river to flow as it has for millennia?

An *economic system* based on human inventiveness and productivity may appear to enable limitless growth, but it disregards the ecological foundation on which economies rest, and it fails to recognize the impossibility of endless growth in a finite world.

Political systems elevate power and responsibility to human beings who are driven by the goal of re-election by servicing those ends defined by voters and corporate lobbyists, while those with the greatest burden of consequences of today's actions have absolutely no influence—namely children, future generations, rivers, forests, marine life, oceans, soil, and groundwater.

Our inability to curb human destructiveness reflects the absence of a framework within which we take and put back into the biosphere, a framework premised on responsibility to the whole.

We hope "The Declaration of Interdependence" provides that framework: a context within which to see our real home—nature—and our responsibility to restore and protect it.

The David Suzuki Foundation
—Thirty Years Later

TARA CULLIS
Co-Founder and president, David Suzuki Foundation

Looking back at the history of the David Suzuki
Foundation thirty years after its humble beginnings,
I am struck by the constant diversity of its activities.
In them I see a determined, hopeful effort to experi-
ment with new ways to reach the Canadian public to
effect change.

It turns out there is no magic bullet. What works
one year needs updating the next.

We have crossed the country on tour after tour,
bringing local and international luminaries together
onstage. We have worked with prime ministers and
schoolchildren, with Indigenous Chiefs and city mayors.
We've tried leading from the front, with television
programs and weekly newspaper articles. We've often
"led laterally" with other allies, knowing, for example,
that sharing expensive research on social change lifts
all boats. Lately, we've tried leading invisibly from
behind, by supporting marches and movements.

Through our digital communications channels—
website, email, and social media—we reach over a

million people weekly. Through news media coverage, millions more. We've worked internationally at UN climate change conferences from Kyoto in 1997 to Madrid in 2019, and we've worked locally creating Butterflyways and Homegrown National Parks in urban neighbourhoods across Canada. We've studied how to communicate (learning how not to turn off Canadians, as much as how to turn them on). We've studied economics, politics, resource extraction, education, GPS mapping, whatever it's taken to achieve each ambitious five-year strategic plan through the decades. We've learned a lot doing it, and we've had a lot of fun along the way.

The 1980s were a decade of ferment and growth in Canada and the world. Battles were won, but the war was being lost. In 1989, David Suzuki's award-winning radio series "It's a Matter of Survival" sounded an alarm, starkly summarizing where the planet was heading. Seventeen thousand of his shocked listeners mailed letters to David with urgent requests for solutions to avert the catastrophe. A growing group of people we respect urged us to create a new, solutions-based organization, one that would concentrate on root causes of our problems rather than their symptoms.

Meetings went on all winter and spring. And thirty years ago, on September 14, 1990, the David Suzuki Foundation was incorporated.

Our early projects were international because our meagre project dollars could go much further overseas, leaving us funds to develop a solid infrastructure at home and time to undergo a thorough planning process

for our Canadian projects. We worked with the Ainu of Japan to protect their salmon, and with OREWA (the Embera-Wounaan Regional Indigenous Organization) in Colombia. We worked with the Kayapo people of Brazil to open the first research station in the lower Amazon, still productive today, and part of a process that preserved the largest tropical forest protected by a single Indigenous group (28.4 million acres/ 11.5 million hectares) in the world. We commissioned research on an effort to take down a dam in Australia and restored a clam fishery with the Hesquiaht First Nation of Vancouver Island. Thirty years later, we have the honour of working with Maial Paiakan on an Indigenous Research Fellowship to help tell her story of Indigenous resistance to vast deforestation to a global audience. Her father, Paulinho—who we worked with thirty years ago and who recently passed of COVID-19—would be proud. With each project, we partnered with local peoples, usually Indigenous, to develop alternative models of economic and community development.

We needed a synopsis of our philosophy—a creed, a call to arms. "The Declaration of Interdependence" gives voice to the guiding principles that underlie our decisions and actions. People say you can't write by committee. It's not true. This document went the rounds among authors many times and, remarkably, became more eloquent with each rewrite. In 1992, when we took the "Declaration" to the UN Earth Summit in Rio, portions were woven into the work of others around the world to form the Earth Charter.

Meanwhile at home, we were learning how to fundraise, keep track of donors, and organize board-staff relations. In 1993, we hired Jim Fulton as our first executive director, and dove into local work. We started with a Social Change conference, publishing the proceedings. Next we launched our first study of sustainability, "Living Within Our Means." Then we began working on forestry with "Chopping Up the Money Tree." We hired our first volunteer coordinator. We discussed problems with fisheries in "Fish on the Line," and then presented solutions from around the world in "Fisheries That Work." Fisheries was also the subject of our first book, *Dead Reckoning* by Terry Glavin. Our second was *The Sacred Balance* by David Suzuki. We have now published eighty books, all in partnership with Greystone Books.

By 1996, we'd ramped up our work on climate change, quickly publishing five reports in the run-up to the Kyoto Conference in 1997. We published research showing salmon fish-farms needed to be transitioned to "closed containment" on-land systems to stop using the oceans as a sewer, a battle we still wage today. On Earth Day 1997, we began a long partnership with the Musqueam First Nation to bring the last salmon stream in Vancouver back to health. Meanwhile, 1998–2004 saw our forestry and fisheries work culminate in the ambitious Salmon Forest Project, leading to a DSF office in Prince Rupert to work with the First Nations communities of the BC central and northern coast, creating local jobs and forming the powerful coast-wide alliance now known as Coastal First Nations (CFN).

We went on to publish landmark guidelines for forestry ecosystem-based management (EBM), and exposés of the overharvesting of cedar. We trained coastal peoples in mapping and inventory of culturally modified trees to help control logging, produced exhaustive annual report cards on Canadian rainforests, and helped launch the Forest Stewardship Council. In fisheries, we funded Dr. Tom Reimchen's research revealing the startling role of salmon in fertilizing the growth of the massive trees of the West Coast watersheds. We began work to protect species at risk; we helped governments ban pesticides. We commissioned research into the contaminants in farmed salmon, exposed the escapes of Atlantic salmon into Pacific waters, litigated against the dumping of dead fish by fish farms, and challenged gravel extraction in the Fraser River. We funded the Leggatt Inquiry into salmon farming, toured the coast in support of the tanker moratorium, and worked with top chefs of British Columbia and Ontario to switch their clientele to sustainable seafood.

People told us they wanted practical steps to sustainability in their own lives. So in 2002, we developed the Nature Challenge, touring the country a year later with speeches and entertainers, culminating in a Discovery Channel TV special. We expanded it to the Nature Challenge for Kids (NC4K), used for years in school curricula, and the Nature Challenge at Work, used by many corporations.

Our climate change team expanded into the health arena with powerful results, working with

doctors across the country to fight for clean air, while publishing alternative energy solutions and lobbying successfully at long last for Canada to sign the Kyoto Protocol. Canada's endorsement set the stage for Russia to agree to sign it, and Kyoto became international law in February 2005. We were proud. We worked with the governments of British Columbia, Manitoba, Ontario, and Quebec to support renewable energy and the carbon tax.

We moved into gardening with David Suzuki Digs My Garden and into households through our Queen of Green and her recipes for everything from laundry soap to green weddings.

Abroad, we used our long experience in the Amazon, the BC coastal rainforest, and the Musqueam watershed to teach conservation planning in the Four Great Rivers region of southeastern Tibet, where we and Future Generations succeeded in protecting a massive area of mountains and forest the size of Italy: the headwaters of the Brahmaputra, Yangtze, Mekong, and Salween, whose waters nourish a third of the people on this planet.

After years of preparation, we moved into economics, assessing the true value of ecosystem services—greenbelts, farmland, and pollination—and published a widely read international guide for businesses working to shrink their footprint.

In 2004, we developed an umbrella strategy, Sustainability Within a Generation (SWAG), a blueprint to sustainability within twenty-five years. In 2007, we

toured the country once more with the "If You Were Prime Minister" bus to spread the message.

We opened our Toronto office and it grew quickly, helping to push through Ontario's *Endangered Species Act* and shut down two proposed coal-fired plants. In 2008, we hired our new CEO, Peter Robinson, from Mountain Equipment Co-op.

In 2008, we saw the birth of our Montreal office, after many years of leadership by volunteers Stephen Bronfman and Les Amis de la fondation. Karel Mayrand came in to lead the office, and he and his team soon established a powerful presence in Montreal and Quebec, and brought bilingualism across the Foundation.

In 2009, we published a widely hailed report showing that Canada can meet the necessary green-house gas targets—without compromising the economy—and Al Gore made our Montreal office his Climate Reality Project headquarters. We started the Ambassadors program to green offices across the country, and launched One Million Acts of Green. In 2010, we helped protect part of the Boreal forest and worked to end the BC grizzly bear trophy hunt.

In 2011, we created the St. Lawrence Coalition, fighting to stop oil and gas drilling in the Gulf. We launched the campaign to establish Rouge National Park around the northern edge of Toronto. We hired multicultural staff to widen and diversify our outreach and languages. We fought for Fish Lake in BC's Chilcotin. And we crafted our Indigenous Peoples

Policy, recognizing Indigenous rights and title and the commitment to engage with First Nations in any environmental project, reflecting our roots in 1990, so many years ago.

In 2012, Soupstock united two hundred top chefs to stop 2,300 acres of fertile farmland from being carved into a limestone quarry. We guided the creation of the Montreal greenbelt, and helped stop the Quebec government's efforts to restart and expand the Jeffrey asbestos mine, which had closed the year before. On Earth Day that year, we worked behind the scenes to bring out 250,000 enthusiastic souls to rally for nature in Montreal.

In 2013, we created Canada's first Homegrown National Park in Toronto. We worked with David Boyd and Ecojustice to launch the national campaign to fight for the right to a healthy environment. That battle led to yet another cross-country expedition in 2014: the Blue Dot Tour of twenty-one towns. Neil Young brought the house down with his thrilling finale in Vancouver.

In Toronto, we planted millions of milkweed plants for the Monarch Butterfly campaign. The Queen of Green grew a wide network of coaches.

In 2014, the Tsilhqot'in First Nation that we'd supported for decades won a huge Supreme Court declaration formally recognizing Aboriginal title for the first time in Canadian history.

In 2015, we launched our Coastal Connections tour of the BC coastal First Nation communities, and calculated the vast natural services (worth between $1 and

$4 billion) that the forests and waters of Howe Sound contribute to Vancouver annually, launching Camp Suzuki there with the Squamish First Nation. With others, we persuaded Ontario to reduce bee-killing pesticides, and Quebec to reject an oil port on the gulf.

By 2016, 40% of Canadians had passed municipal declarations supporting the Right to a Healthy Environment. We published caribou and biodiversity reports with the Doig River and Blueberry River First Nations. Fighting for sustainable seafood, we exposed weak government labelling and lack of traceability. We criticized Canada's flawed new Oceans Protection Plan. And staff scientist Scott Wallace helped negotiate a global precedent to protect sponges and corals, the Pacific Groundfish Trawl Habitat Agreement. We also launched our Fellowship program, boosting our first three outstanding young climate scholars, working in economics, transportation, and Indigenous knowledge.

In 2017, our Butterflyway project, launched from the success of the Homegrown National Park Rangers, took off in BC, Ontario, and Quebec. Staff scientist John Werring exposed methane pollution from orphan fracked well sites in BC. We supported Grassy Narrows, grizzly bears, and snapping turtles, and mobilized to cancel the Energy East pipeline project. As Peter Robinson retired after ten productive years, we hired our new CEO, Stephen Cornish, the former head of Médecins sans frontières Canada.

Charged Up was launched in 2018, amplifying clean-tech success stories across the country. Eleven Natural Assets communities boosted health and fought

climate change. Five hundred scientists supported the Blue Dot initiative, and the Foundation published reports on healthy transportation in Montreal, Toronto, and Vancouver. Our report on clean drinking water exposed systemic failures for more than one hundred First Nations in Canada without access to potable water.

In 2019, to protect caribou, we launched an interactive online map. We launched Clean Power Pathways—Canada's first-ever national study of decarbonization through the use of renewable energy. Our Montreal office spearheaded Greta Thunberg's visit and a youth climate march 500,000 strong; 120,000 marched in solidarity in Vancouver. Then we welcomed Greta to Vancouver, and helped launch the *La Rose v. Her Majesty the Queen* youth climate lawsuit—our country's first national lawsuit against the government for its systemic actions to perpetuate dangerous climate change.

Interest in the environment seems to peak in thirty-year generations. It feels as if we've now lived and worked through one complete cycle, from the fervour of interest in the Amazon and old-growth local forests in the late eighties, to the rising fever of youth-led climate marches of the late 2010s and the 2020s.

Despite our best efforts, we have not yet turned the corner to a wiser future. But we and the public have come a very long way. As I write this, we find ourselves in a steep but oddly hopeful learning curve as we grapple with the COVID-19 pandemic. As we study pandemic responses around the world, we and our allies see the opportunity to inform and develop new

strategies for creating the green, equitable, sustainable future we've been working toward for so long.

Throughout all this, "The Declaration of Interdependence" has stood the test of time. Acting as a backbone from which the great variety of our activities radiates out, it ties everything together. Its message of interconnectedness is more relevant today than ever, and its words continue to inspire us. We hope it inspires you too.

Contributor Bios

TARA CULLIS is an award-winning writer and co-founder and president of the David Suzuki Foundation. She has been a key player in environmental movements in the Amazon, Southeast Asia, and British Columbia. Dr. Cullis has been adopted and named by the Haida, the Gitga'at, the Heiltsuk, and the 'Namgis First Nations.

Award-winning geneticist and broadcaster DAVID SUZUKI has written more than forty books and is a world leader in sustainable ecology. For his support of Canada's First Nations people, Dr. Suzuki has been honoured with six names and formal adoption by two tribes. He was awarded the 2009 Right Livelihood Award in recognition of his long commitment to raising awareness of climate change issues.

WADE DAVIS is a writer, photographer, and filmmaker whose work has taken him from the Amazon to Tibet, Africa to Australia, Polynesia to the Arctic. Explorer in Residence at the National Geographic Society (NGS) from 2000 to 2013, he is currently professor of anthropology and the BC Leadership Chair in Cultures and Ecosystems at Risk at the University of British Columbia. Author of twenty-three books, including *One River, The Wayfinders,* and *Into the Silence,* and winner of the 2012 Samuel Johnson Prize, the top nonfiction prize in the English language, he holds degrees in anthropology and biology and received his Ph.D. in ethnobotany, all from Harvard University. His many film credits include *Light at the Edge of the World,* an eight-hour documentary series written and produced for the NGS. Davis, one of twenty Honorary Members of the Explorers Club, is the recipient of twelve honorary degrees, as well as the 2009 Gold Medal from the Royal Canadian Geographical Society, the 2011 Explorers Club Medal, the 2012 David Fairchild Medal for botanical exploration, the 2015 Centennial Medal of Harvard University, the 2017 Roy Chapman Andrews Society Distinguished Explorer Award, the 2017 Sir Christopher Ondaatje Medal for Exploration, and the 2018 Mungo Park Medal from the Royal Scottish Geographical Society. In 2016, he was made a Member of the Order of Canada. In 2018, he became an Honorary Citizen of Colombia. His latest book, *Magdalena: River of Dreams,* was published by Knopf in September 2020.

GUUJAAW is a singer, carver, traditional medicine practitioner, and former president of the Haida Nation of the North Pacific coast. His love for the land and understanding of the vulnerability of life has led him to devote much of his life to fighting the forces that are damaging the planet.

RAFFI CAVOUKIAN, C.M., is a renaissance man known to millions simply as Raffi: a renowned children's troubadour, music producer, systems thinker, author, entrepreneur, ecology advocate, and founder of Child Honouring.
raffinews.com

MICHAEL NICOLL YAHGULANAAS's art is informed by years of political activism, mostly on behalf of the Haida. His work—including "Haida manga," the distinctive art form for which he is widely known—riffs on traditional techniques. Yahgulanaas has devoted much of his life to working with other Haida people to prevent their homeland from being logged.
mny.ca

The David Suzuki Institute

The David Suzuki Institute is a non-profit organiza-
tion founded in 2010 to stimulate debate and action
on environmental issues. The Institute and the David
Suzuki Foundation both work to advance awareness of
environmental issues important to all Canadians.

We invite you to support the activities of the
Institute. For more information please contact us at:

David Suzuki Institute
219 – 2211 West 4th Avenue
Vancouver, BC, Canada V6K 4S2
info@davidsuzukiinstitute.org
604-742-2899
davidsuzukiinstitute.org

Cheques can be made payable to The David Suzuki
Institute.

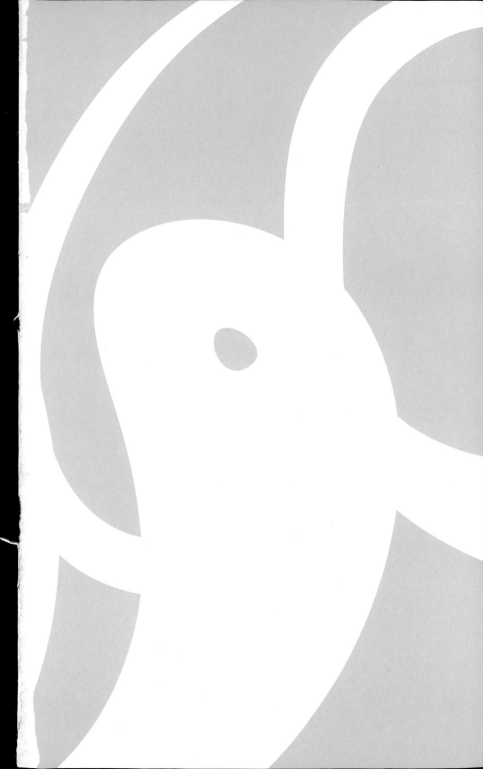